PICTURE PALACES

Nothing lights up a street at night like a movie marquee. Since the first nickelodeons opened their doors, just after the turn of the century, movies and movie houses have been a mainstay of American life. Nickelodeons were rapidly replaced by larger theaters, more elaborate inside and out. Our city streets once were lined with these showplaces. In the 1920s, when the Strip in Las Vegas was just a twinkle in a developer's eye, Theatre Row shone in Dallas. And that glittery avenue could be matched in Denver and Minneapolis — and in many other American cities. The extraordinary wattage lighting up New York's Times Square in those years came from picture palaces, not from advertising signs.

The boom was nationwide. Just as the movies took hold of our imaginations, the fancy-fronted picture palaces captured our hearts. Movie houses became the principal source of entertainment, from a rainy-day matinee to a night on the town. Places with names such as the Idle Hour speak to us of seeing a motion picture show on a quiet summer evening. The Dreamland Theatre sounds like a racier spot, although it did promote itself as "a fit place for Mother, Sister, and Sweetheart" — presumably not all at the same movie. What the name "Dreamland" most clearly evokes is the capacity of the movies to transport us to other worlds. This feat was matched in the 1920s by the architects of the movie palaces. Stylistic motifs were borrowed from virtually every known civilization, resulting in theater interiors that could pass for a Dutch town, a Mayan tomb, an East Indian temple, a Chinese throne room or the court at Versailles. Five years before he opened his world-famous Chinese Theatre in 1927, Sid Grauman had a little piece of the Nile re-created farther east on Hollywood Boulevard as the Egyptian Theatre. And a few theaters, such as the KiMo in Albuquerque, with its Pueblo Indian decor, were truly unique. The sense of fantasy was carried to an extreme in auditoriums constructed beneath blue plaster "skies"

filled with pinlight "stars." Known as atmospherics, these illusionistic theaters were pioneered by architect John Eberson in places such as his Tampa Theatre in Florida.

Movie theaters were part of Main Street U.S.A. For every grand showplace like the Roxy in Manhattan, boasting more than 5,000 seats, a hundred small-town theaters opened as the Colonial, the Tivoli or the Alhambra. Decorative elements were often added for special occasions or just to mark the holidays — flags for the local Fourth of July parade, Santa and his reindeer atop the marquee in early December. A look at many present-day marquees shows only blank faces. But people who love theaters are changing the prospects for these vacant and underused showplaces. Theater reuse has come to mean common sense where a town needs more space for cultural activities, a forum for local events or an attraction to boost tourism.

Often gaudy, always colorful, picture palaces have always been close to our hearts. This book of postcards is a sampling of only a few of our great theaters, and, regrettably, many of those pictured here are gone. Those that remain should be treasured as storehouses of our collective memories.

David Naylor

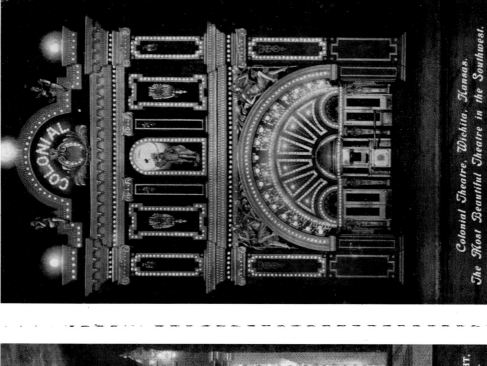

Colonial Theatre, Wichita, Kansas.
The Most Beautiful Theatre in the Southwest.

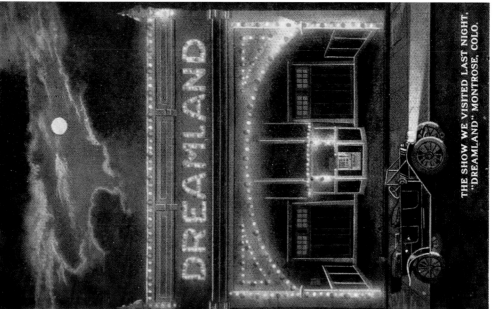

THE SHOW WE VISITED LAST NIGHT.
"DREAMLAND" MONTROSE, COLO.

COLONIAL THEATRE

WICHITA, KANS. 1910; DEMOLISHED. c. 1913 view, Curt Teich Postcard
Collection, Lake County (Ill.) Museum. From *Picture Palaces.* © 1988
National Trust for Historic Preservation. The Preservation Press.

DREAMLAND THEATRE

MONTROSE, COLO. 1890; 1912; REMODELED. c. 1912 view, Curt Teich
Postcard Collection, Lake County (Ill.) Museum. From *Picture Palaces.*
© 1988 National Trust for Historic Preservation. The Preservation Press.

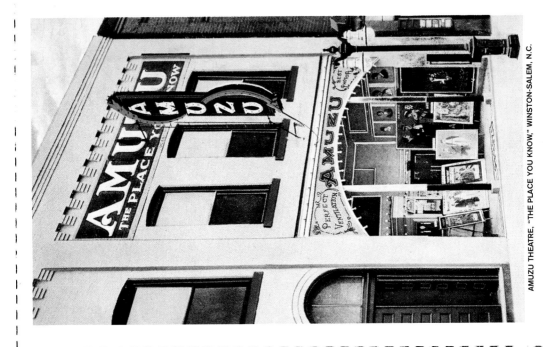

AMUZU THEATRE, "THE PLACE YOU KNOW," WINSTON-SALEM, N.C.

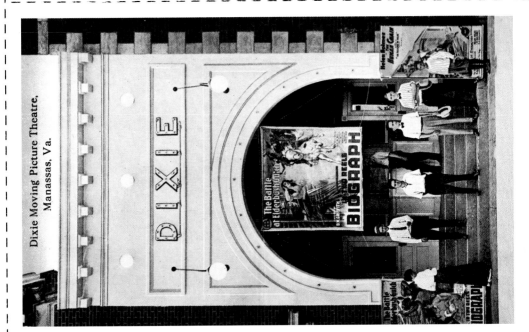

Dixie Moving Picture Theatre,
Manassas, Va.

AMUZU THEATRE

WINSTON-SALEM, N.C. 1911; DEMOLISHED. c. 1917 view, Curt Teich
Postcard Collection, Lake County (Ill.) Museum. From *Picture Palaces*.
© 1988 National Trust for Historic Preservation. The Preservation Press.

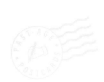

DIXIE MOVING PICTURE THEATRE

MANASSAS, VA. c. 1915; REMODELED. 1915 view, Curt Teich Postcard
Collection, Lake County (Ill.) Museum. From *Picture Palaces*. © 1988
National Trust for Historic Preservation. The Preservation Press.

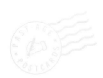

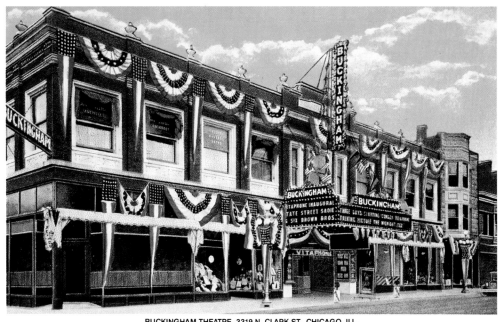

BUCKINGHAM THEATRE, 3319 N. CLARK ST., CHICAGO, ILL.

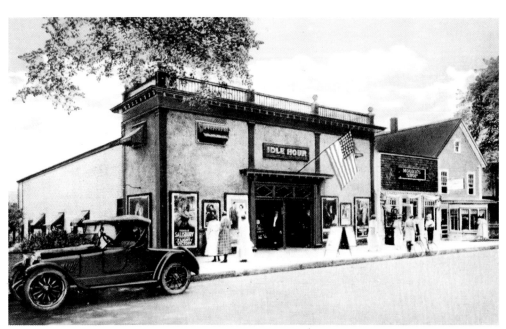

IDLE HOUR THEATRE, HYANNIS, MASS.

BUCKINGHAM THEATRE

CHICAGO, ILL. 1913; REMODELED. 1929 view, Curt Teich Postcard
Collection, Lake County (Ill.) Museum. From *Picture Palaces.* © 1988
National Trust for Historic Preservation. The Preservation Press.

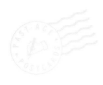

IDLE HOUR THEATRE

HYANNIS, MASS. BURNED. c. 1920 view, Curt Teich Postcard Collection,
Lake County (Ill.) Museum. From *Picture Palaces.* © 1988 National Trust
for Historic Preservation. The Preservation Press.

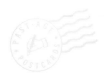

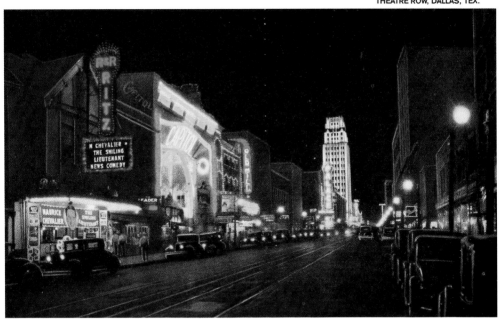

THEATRE ROW, DALLAS, TEX.

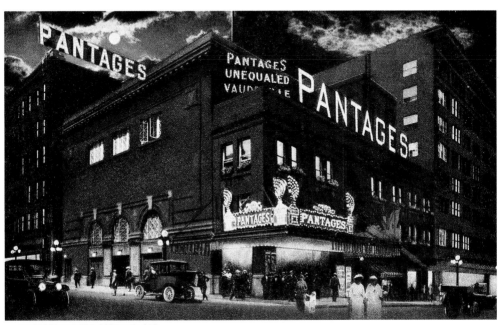

PANTAGES THEATRE, PORTLAND, ORE.

THEATRE ROW

DALLAS, TEX. NOW ELM STREET. 1931 view, Curt Teich Postcard
Collection, Lake County (Ill.) Museum. From *Picture Palaces.* © 1988
National Trust for Historic Preservation. The Preservation Press.

PANTAGES THEATRE

PORTLAND, ORE. 1912; DEMOLISHED. c. 1915 view, Curt Teich Postcard
Collection, Lake County (Ill.) Museum. From *Picture Palaces.* © 1988
National Trust for Historic Preservation. The Preservation Press.

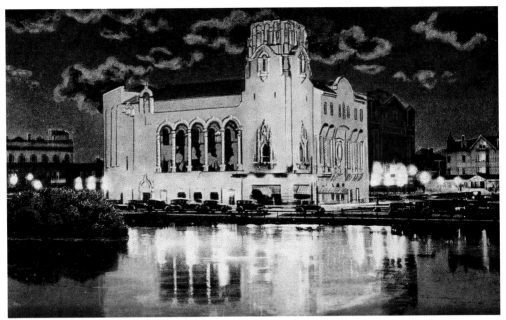

NIGHT VIEW OF MAYFAIR THEATRE, ASBURY PARK, N.J.

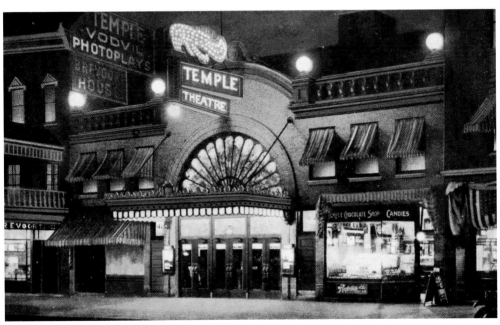

TEMPLE THEATRE, BY NIGHT, GENEVA, N.Y.

MAYFAIR THEATRE

ASBURY PARK, N.J. 1927; DEMOLISHED. 1930 view, Curt Teich Postcard
Collection, Lake County (Ill.) Museum. From *Picture Palaces.* © 1988
National Trust for Historic Preservation. The Preservation Press.

TEMPLE THEATRE

GENEVA, N.Y. 1911; DEMOLISHED. c. 1917 view, Curt Teich Postcard
Collection, Lake County (Ill.) Museum. From *Picture Palaces.* © 1988
National Trust for Historic Preservation. The Preservation Press.

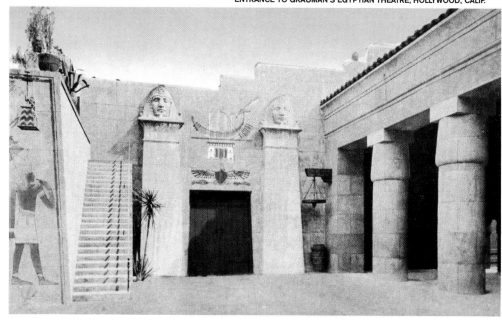

ENTRANCE TO GRAUMAN'S EGYPTIAN THEATRE, HOLLYWOOD, CALIF.

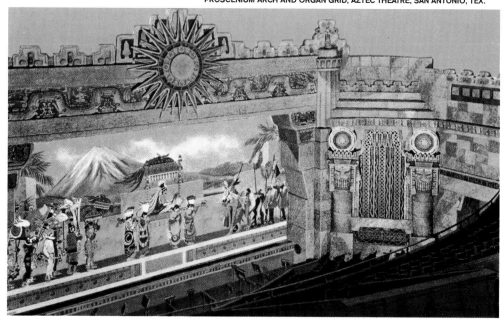

PROSCENIUM ARCH AND ORGAN GRID, AZTEC THEATRE, SAN ANTONIO, TEX.

GRAUMAN'S EGYPTIAN THEATRE

HOLLYWOOD, CALIF. 1922. 1924 view, Curt Teich Postcard Collection, Lake County (Ill.) Museum. From *Picture Palaces*. © 1988 National Trust for Historic Preservation. The Preservation Press.

AZTEC THEATRE

SAN ANTONIO, TEX. 1926. c. 1927 view, Curt Teich Postcard Collection, Lake County (Ill.) Museum. From *Picture Palaces*. © 1988 National Trust for Historic Preservation. The Preservation Press.

GRAND RIVIERA THEATRE, GRAND RIVER AVENUE, DETROIT, MICH.

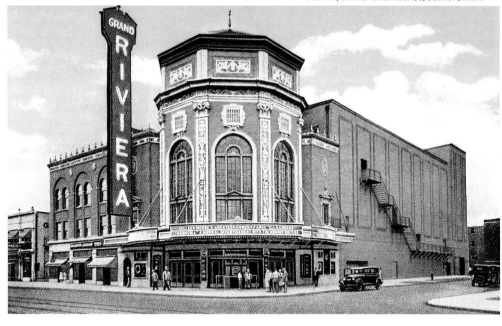

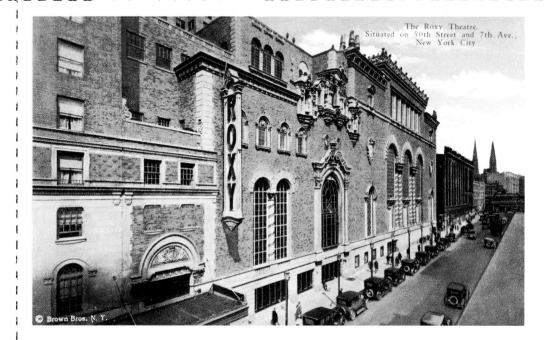

The Roxy Theatre.
Situated on 50th Street and 7th Ave.,
New York City

© Brown Bros. N.Y.

GRAND RIVIERA THEATRE

DETROIT, MICH. 1924. c. 1927 view, Curt Teich Postcard Collection, Lake
County (III.) Museum. From *Picture Palaces.* © 1988 National Trust for
Historic Preservation. The Preservation Press.

ROXY THEATRE

NEW YORK, N.Y. 1927; DEMOLISHED. c. 1927 view, Curt Teich Postcard
Collection, Lake County (III.) Museum. From *Picture Palaces.* © 1988
National Trust for Historic Preservation. The Preservation Press.

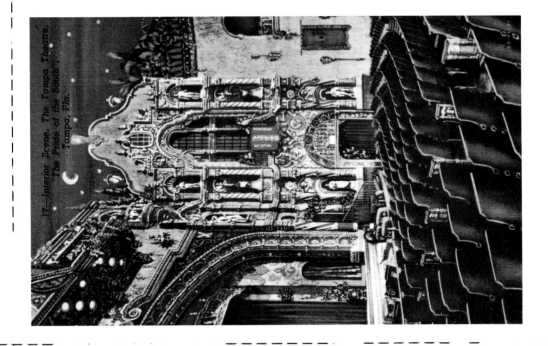

17—Interior Scene. The Tampa Theatre. "The Pride of the South." Tampa, Fla.

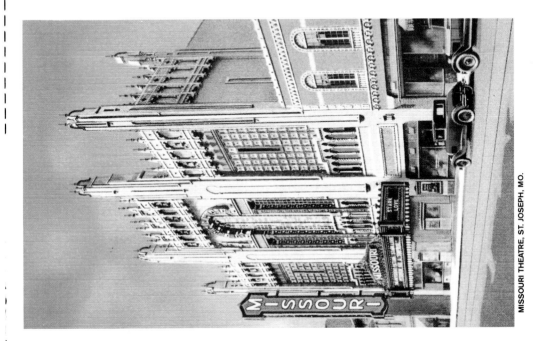

MISSOURI THEATRE, ST. JOSEPH, MO.

TAMPA THEATRE

TAMPA, FLA. 1926. 1940 view, Curt Teich Postcard Collection, Lake County
(Ill.) Museum. From *Picture Palaces.* © 1988 National Trust for Historic
Preservation. The Preservation Press.

MISSOURI THEATRE

ST. LOUIS, MO. 1920; DEMOLISHED. c. 1926 view, Curt Teich Postcard
Collection, Lake County (Ill.) Museum. From *Picture Palaces.* © 1988
National Trust for Historic Preservation. The Preservation Press.

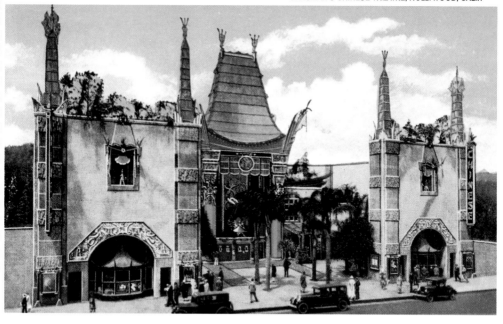

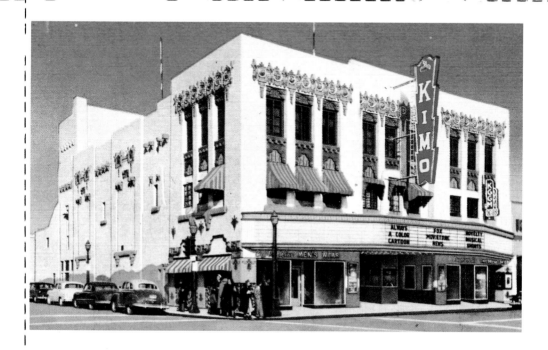

GRAUMAN'S CHINESE THEATRE

HOLLYWOOD, CALIF. 1927. c. 1927 view, Curt Teich Postcard Collection,
Lake County (Ill.) Museum. From *Picture Palaces*. © 1988 National Trust
for Historic Preservation. The Preservation Press.

KIMO THEATRE

ALBUQUERQUE, N.M. 1927. 1951 view, Curt Teich Postcard Collection, Lake
County (Ill.) Museum. From *Picture Palaces*. © 1988 National Trust for
Historic Preservation. The Preservation Press.

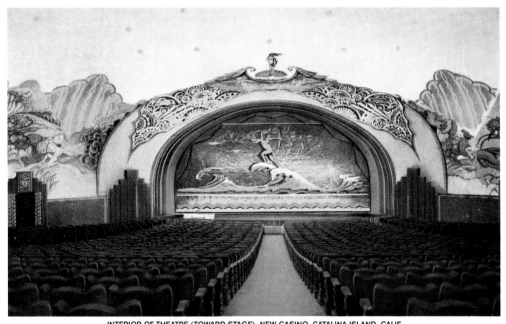

INTERIOR OF THEATRE (TOWARD STAGE), NEW CASINO, CATALINA ISLAND, CALIF.

IN THE HEART OF MAYSVILLE

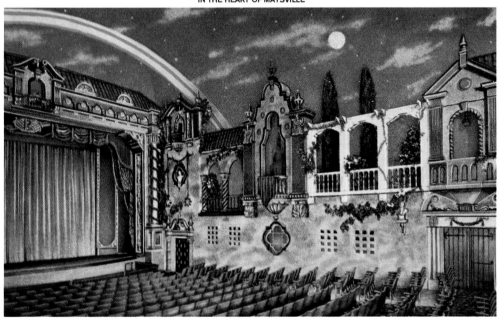

THE RUSSELL THEATRE, MAYSVILLE, KY.

AVALON THEATRE

CATALINA ISLAND, CALIF. 1929. 1929 view, Curt Teich Postcard Collection,
Lake County (Ill.) Museum. From *Picture Palaces.* © 1988 National Trust
for Historic Preservation. The Preservation Press.

RUSSELL THEATRE

MAYSVILLE, KY. 1929. 1930 view, Curt Teich Postcard Collection, Lake
County (Ill.) Museum. From *Picture Palaces.* © 1988 National Trust for
Historic Preservation. The Preservation Press.

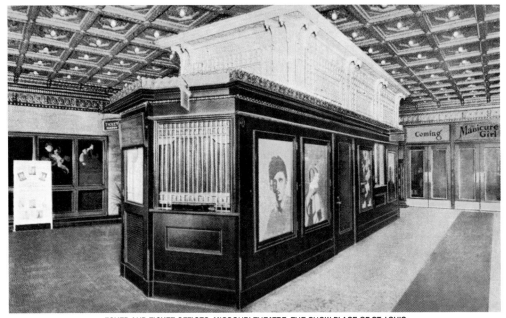

FOYER AND TICKET OFFICES, MISSOURI THEATRE, THE SHOW PLACE OF ST. LOUIS

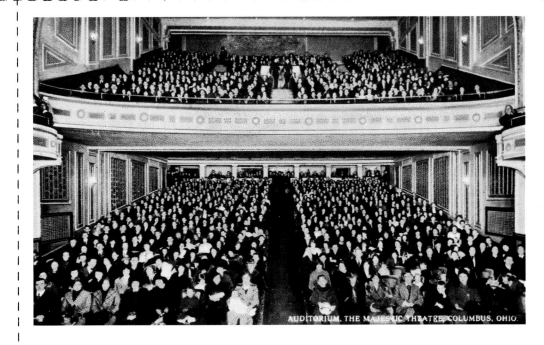

AUDITORIUM, THE MAJESTIC THEATRE, COLUMBUS, OHIO.

MISSOURI THEATRE

ST. JOSEPH, MO. 1927. 1932 view, Curt Teich Postcard Collection, Lake
County (Ill.) Museum. From *Picture Palaces.* © 1988 National Trust for
Historic Preservation. The Preservation Press.

MAJESTIC THEATRE

COLUMBUS, OHIO. 1914; DEMOLISHED. 1914 view, Curt Teich Postcard
Collection, Lake County (Ill.) Museum. From *Picture Palaces.* © 1988
National Trust for Historic Preservation. The Preservation Press.

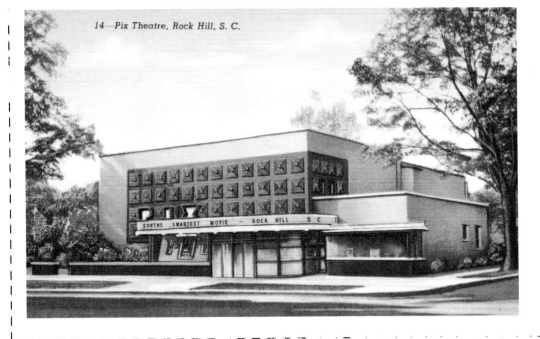

14—Pix Theatre, Rock Hill, S. C.

VARSITY THEATRE, MARTIN, TENN.

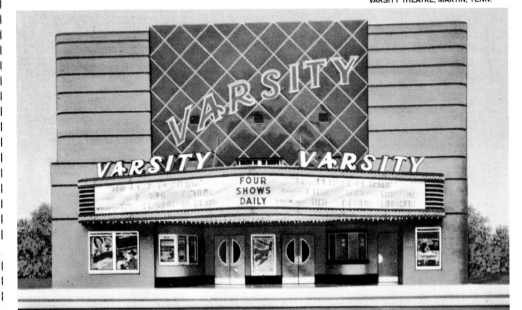

PIX THEATRE

ROCK HILL, S.C. 1940; DEMOLISHED. 1944 view, Curt Teich Postcard
Collection, Lake County (Ill.) Museum. From *Picture Palaces.* © 1988
National Trust for Historic Preservation. The Preservation Press.

VARSITY THEATRE

MARTIN, TENN. 1949. 1950 view, Curt Teich Postcard Collection, Lake
County (Ill.) Museum. From *Picture Palaces.* © 1988 National Trust for
Historic Preservation. The Preservation Press.

VIEWS FROM AMERICA'S PAST

The Russell Theatre in Maysville, Ky., was new once. In 1930, when a postcard was printed to celebrate the year-old picture palace, the Russell must have been an amazing sight. On the outside, with its urn-topped towers and twisting columns, the theater looked like a bit of Spain transported to Kentucky. Inside, it was always a night in Spain, a feeling helped along by the almost-real architecture of an arcaded garden loggia draped with flowers. It was a place described on the back of the postcard as

> *Where the clouds roll by*
> *The "Stars" twinkle*
> *The "Moon" rises and*
> *The "Rainbow" arches the sky.*

Maysville's second movie theater, the Russell was decorated in an atmospheric style to help theater patrons imagine themselves sitting under the canopy of a Mediterranean star-filled sky. Today, the Russell's stars twinkle down on an empty auditorium, while the theater awaits its fate along with many other picture palaces. The postcard still celebrates the Russell, however, just as all the other postcards in this selection celebrate these theaters from our past — some gone, some still around. The postcards record these theaters for us even as the theaters themselves change or disappear.

Preserving a visual record of the changing appearance of American communities was not why postcards were originally printed. The postcard industry was a business like any other, and the goal was to make money. At the turn of the century, view postcards were one of the early commercial uses of photography, appearing at a time when owning your own camera was still unusual, even rare.

Postcards filled the role of documenting places and events, familiar and unfamiliar alike, in much the same way as people themselves would have done – all for the accessible price of one penny. Postcards recorded anything and everything that could be photographed, printed and sold. They documented where Americans went on vacation, how they got there and what they saw along the way. They preserved moments of patriotism and unknowingly traced issues of national concern such as segregation. Today, the view postcards printed in the past 90 years by companies across the United States are a visual microcosm of American life in the 20th century. They are also a valuable resource for historians, city planners, corporations, interested individuals and even set designers seeking to re-create a specific locale.

One of the largest postcard companies began when Curt Teich, a German immigrant, hopped a train headed west out of Chicago. Each time the train stopped, Teich would get off, identify and photograph local points of interest and persuade a town retailer to stock and sell the views. In those early days the minimum order was 1,000 cards of a subject at $1 per thousand. On his first 90-day trip, Teich sold $30,000 worth of his idea, and he was in business. From this auspicious beginning the Curt Teich Company grew to become the largest volume printer of view and advertising postcards in the United States, operating from 1898 to 1974. The company's archives now are preserved as the Curt Teich Postcard Collection at the Lake County (Ill.) Museum. The postcards here were selected by the museum and the publisher from 300,000 original images. These views represent the unique resources of the collection, while they document an equally unique – and endangered – part of our past.

Katherine Hamilton-Smith